MW01012212

today's artist dvd series

Drawing for the Beginner Workshop

Mark and Mary Willenbrink

NORTH LIGHT BOOKS
CINCINNATI, OHIO
www.artistsnetwork.com

Contents

Introduction

Do you remember when you got out your crayons and drew pictures as a child? Now maybe you are proudly displaying your children's artwork on the refrigerator door. You love their pictures because you can see their unique expression in the art, even if it looks more like a Picasso than a Rembrandt. You were just as proud of your own artwork at one time but somewhere along the road of life you began to doubt your artistic abilities. Our belief is that everyone is an artist, and that includes you!

We hope you will regain that childlike passion for doing art and learning without critiquing yourself harshly. We won't make you hang it on the fridge, but we do suggest you save your artwork because it will show your progress and increase your confidence as you go.

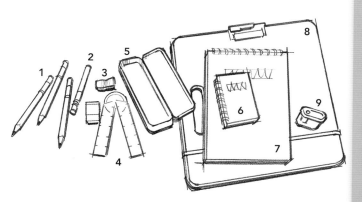

YOU NEED ONLY A FEW MATERIALS TO DRAW

All you really need is a pencil and some paper, but a few other tools will make drawing easier wherever you go.

1 Pencils
2 Pencil extender
3 Erasers
4 Angle ruler
5 Pencil box
6 Small sketch pad
7 Large drawing pad
8 Drawing board
9 Pencil sharpener

MUST-HAVE MATERIALS

- 4H, HB and 4B graphite pencils
- Pencil sharpener
- Sketch pad
- 11" × 14" (28cm × 26cm) medium-tooth drawing paper
- Drawing board
- Kneaded eraser
- White vinyl eraser

OPTIONAL, BUT NOT TO BE OVERLOOKED

- Straightedge, triangle or angle ruler
- Light box
- Dividers, proportional dividers or sewing gauge
- Small mirror
- Erasing shield
- Pencil extender
- Craft knife
- Sandpaper pad
- T-square
- Fixative
- Tracing paper
- Masking tape

Pencils

There are many different types of pencils to choose from. One difference among pencils is the core, which may be made of *graphite, carbon* or *charcoal*. I especially like the graphite (commonly mislabeled lead) pencil because it can easily be erased, it comes in many degrees of firmness and it does not easily smear. Carbon and charcoal pencils provide rich, dark colors but they don't erase as well, smear easily and have a very soft feel. Black colored pencils don't smear, but they don't erase well and have a firm but waxy feel.

PENCIL HARDNESS
Hardness is another important quality to consider. Ratings, usually stamped on the pencils, range from H (hard) to B (soft), with F and HB in the middle.

WOODLESS PENCILS
Woodless pencils have only a thin coating over their thick cores. This is a novel idea, but woodless pencils are prone to breaking, especially when carried in a pocket! Use pencils with wood surrounding the core instead.

RUNAWAY PENCILS!
Use hex-shaped pencils instead of round pencils because round pencils roll and can get away from you.

PENCIL EXTENDER
To get more miles out of your pencils, use a pencil extender on the end of a pencil that has been shortened by use.

PENCILS COME IN A VARIETY OF HARDNESSES

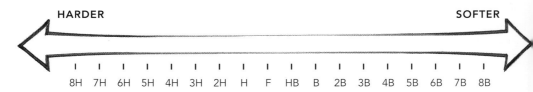

HARDER SOFTER

| 8H | 7H | 6H | 5H | 4H | 3H | 2H | H | F | HB | B | 2B | 3B | 4B | 5B | 6B | 7B | 8B |

Keeping Your Pencil Sharp

If you want to draw a thin line, you will need a sharp point on the tip of your pencil. You can sharpen your pencils in two ways: with a *pencil sharpener* or by hand, using a *craft knife* and a *sandpaper pad*.

PENCIL SHARPENERS ARE THE SIMPLEST WAY TO KEEP PENCILS SHARP

A pencil sharpener is the quickest and easiest way to keep the tips of your pencils sharp.

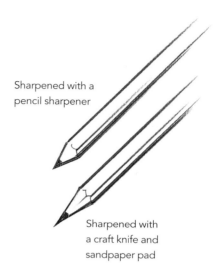

Sharpened with a pencil sharpener

Sharpened with a craft knife and sandpaper pad

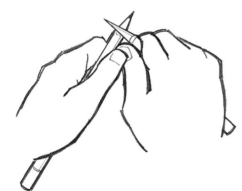

A CRAFT KNIFE AND SANDPAPER PAD REVEAL MORE OF THE PENCIL'S CORE

For a controlled point that exposes more of the core, sharpen your pencil with a craft knife and sandpaper pad.

FIRST SHAPE THE PENCIL WITH A CRAFT KNIFE ▲

Grip the pencil in one hand, with the point away from you, and the craft knife in the other. Push the thumb holding the pencil against the thumb holding the knife to create leverage so the blade cuts into the pencil. Cut, then turn the pencil and repeat the process until you've worked the area into a point.

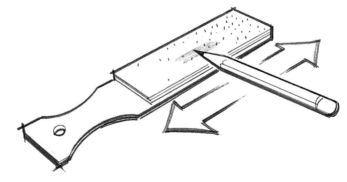

THEN SHARPEN THE CORE WITH A SANDPAPER PAD ▲

Sand the core back and forth on the sanding pad for a sharp point.

Paper and Drawing Board

When choosing drawing paper, always choose an *acid-free paper,* or the paper may yellow over time. *Sketch paper,* as the name implies, is for sketching and usually has a *paper weight* of 50 to 70 lbs. (105gsm to 150gsm). *Drawing paper,* which is for more finished art, usually comes in 90-lb. (190gsm) weight. A small 6" × 4" (15cm × 10cm) pocket sketch *pad* is great for quick studies and ideas, while larger sketch pads are obviously needed for bigger sketches. Any drawing you begin may be completed as a keeper, so you may prefer to begin all your drawings using an 11" × 14" (28cm × 36cm) medium-tooth, acid-free, 90-lb. (190gsm) drawing paper.

The lights and darks in a drawing are achieved by varying the amount of pressure applied to the pencil. Because of this, it is necessary to have a hard surface beneath the paper, ideally a *drawing board.* It offers a smooth, solid surface without surprise ruts or nicks, and it won't bend or give with pressure the way the cardboard back of a drawing pad can.

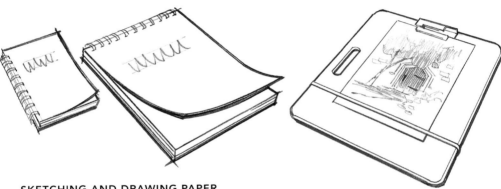

SKETCHING AND DRAWING PAPER
Use both a small sketch pad and a larger drawing pad. Tear out the individual drawing pad sheets and use them on a drawing board.

DRAWING BOARDS PROVIDE A HARD, SMOOTH SURFACE
Drawing boards can be bought with a clip attached to one end and a rubber band on the other to hold a sheet of paper in place.

TRACING PAPER AND MASKING TAPE

Use *tracing paper* to make a more refined sketch. Put the previous sketch under the top sheet of tracing paper. Use masking tape to secure the sheets of paper to each other, then carefully trace the desired elements of the image onto the tracing paper.

Erasers

Erasers are the sort of thing to have with the idea that you will use them only sparingly. Each time you use an eraser, you risk smearing the drawing or damaging the paper.

KNEADED ERASER

The first eraser you get should be a *kneaded eraser*. These soft, putty-like erasers are very gentle to the paper's surface and leave few, if any, crumbs. To erase, first try pressing the eraser to the paper's surface; this is less damaging to the paper than rubbing the eraser back and forth.

WHITE VINYL ERASER

Use a *white vinyl eraser* to remove hard-to-erase pencil lines. White vinyl erasers are more abrasive than kneaded erasers but will not stain the paper, as some colored erasers often do. White vinyl erasers leave behind strings rather than crumbs, making cleanup easy.

ERASING SHIELD

Made of thin metal, an *erasing shield* masks the areas that are not to be erased. To use it, with one hand firmly hold the shield down over the area not to be disturbed and, with your other hand, carefully erase over top of the shield.

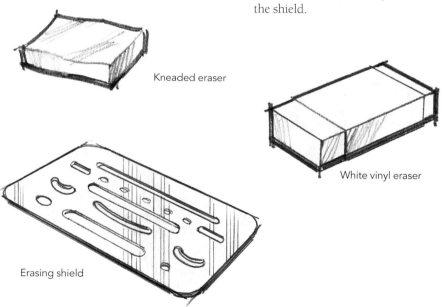

Kneaded eraser

White vinyl eraser

Erasing shield

AVOID USING THE ERASER AT THE END OF YOUR PENCIL

Never use the eraser at the end of a pencil. It may smear pencil lines and stain the paper.

Additional Drawing Tools

STRAIGHTEDGE

Using a *straightedge* will give you sharp, accurate lines when your subject is technical and requires precision. The precision from a straightedge would look awkward in a sketchy drawing, though. If you want straightedge accuracy without the tightness, use the straightedge during the sketching stage with a light pencil line, then draw over those lines more heavily freehand in the drawing stage.

TRIANGLE

Because it is larger than a ruler and has more surface area to grip, a *triangle* can be easy to use for drawing straight lines.

T-SQUARE

Using a triangle with a *T-square* hooked to the side edge of your board or drawing pad will help you draw more precise vertical, horizontal and diagonal lines.

ANGLE RULER

An *angle ruler* works like a ruler, but it can pivot to measure angles and can fold small enough to fit in a pencil box.

DIVIDERS

Dividers are used to observe and duplicate proportions from a photo or sketch.

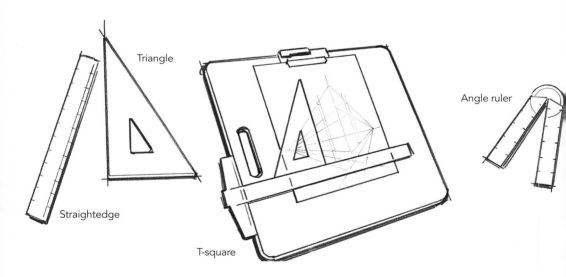

Triangle

Angle ruler

Straightedge

T-square

PROPORTIONAL DIVIDERS

Proportional dividers are used to proportionally enlarge or reduce a image.

SEWING GAGE

A *sewing gauge* is an inexpensive tool that can be used to measure the proportions of a still life, three-dimensional subject matter, or when working from flat reference materials such as photographs.

LIGHT BOX

A *light box* allows you to work from a structural drawing without having to sketch guidelines directly on your drawing paper.

SMALL MIRROR

Use a small mirror for self-portraits and for observing facial features. It is also handy for examining your artwork in reverse form. Looking at a drawing in reverse will allow you to see the composition through fresh eyes.

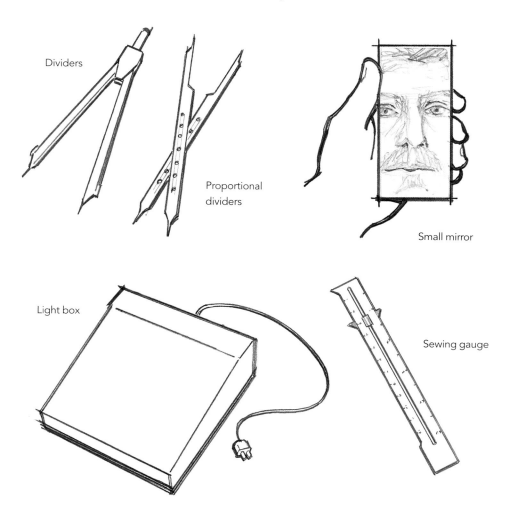

Dividers

Proportional dividers

Small mirror

Light box

Sewing gauge

Holding the Pencil

There are different ways to hold a pencil, depending on what type of strokes and lines you want to achieve. You may start out with loose, sketchy lines and progress to tighter, more controlled lines and shorter strokes. Here are some common hand grips you can try as you sketch and draw. You may find something else that works better for you. You will find that pressure and grip affects the line results of your drawings. Generally, the more pressure you apply, the darker your line will be.

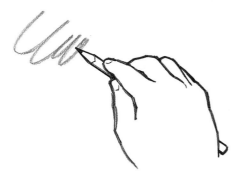

CREATE THICK, LOOSE LINES

For thick, loose lines, avoid using the point of the pencil. Instead, grip the pencil with your thumb and fingertip so that the pencil lead lies flat against the paper. Your fingertips should be either just above the paper surface or gently resting on it. This may smear your previous pencil lines, so be careful. You will use your entire arm to draw these wide lines.

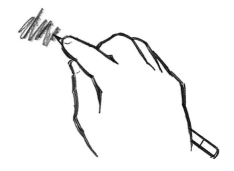

CREATE THICK, TIGHT LINES

Apply more pressure to the point of the pencil by moving your index finger closer to the tip. Your fingertips may rest on the paper, though it isn't necessary that they do so for this stroke to be successful.

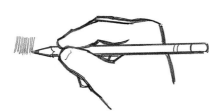

CREATE THIN, CONTROLLED LINES

For lines like these, grip the pencil as in a handwriting position, with the pencil resting between your thumb, middle and index fingers. Your hand rests gently on the paper. For very thin lines, the pencil tip needs to come to a sharp point.

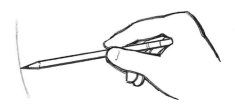

CREATE LONG, ARCING LINES

This grip is similar to the handwriting position, except you hold the pencil out at length. Use this grip to achieve wide, straight and arced lines. Let your hand rest gently on the paper.

Structural Sketch of a Coffee Cup

A structural sketch helps you see how a subject is constructed. Look for basic shapes such as squares, rectangles and circles. Now ask yourself how they relate to one another. Before you pick up your pencil to sketch your coffee cup, take a minute to study your subject.

MUST-HAVE MATERIALS

4H graphite pencil
Drawing paper
Kneaded eraser
Straightedge (optional for the first step, absolutely prohibited for the rest of the steps)

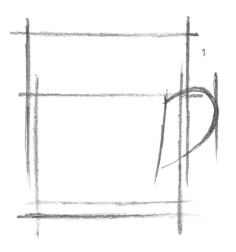

1

Structural guideline

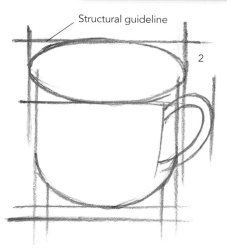

2

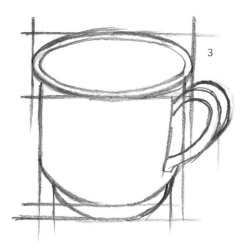

3

1 SKETCH THE BASIC FORM AND STRUCTURES

Use a 4H pencil to sketch the outer forms of the mug and the most relevant structural guidelines, such as those that will indicate the placement of the rim, the bottom of the cup and the handle.

2 ADD MORE STRUCTURAL LINES

Sketch the rim of the cup and the handle. Use the lines you drew in step one to help you add these additional lines. Look for points where elements line up such as the rim of the cup and handle.

3 ADD DETAIL LINES TO FINISH

Add details such as the inner lines of the rim and handle. Erase any unnecessary guidelines with a kneaded eraser.

Value Sketches

Values are the degrees of lights and darks in a drawing or painting. A *value sketch* is used to observe a subject without much regard for structural or proportional accuracy. Here you focus on the lights and darks of your subject. One way to visually separate the structural lines from the values is to squint at your subject. This blurs the structural lines and makes the lights and darks more noticeable. For a finished drawing that employs values, it's a good idea to do a structural sketch first to make sure the elements of your subject are in the right places.

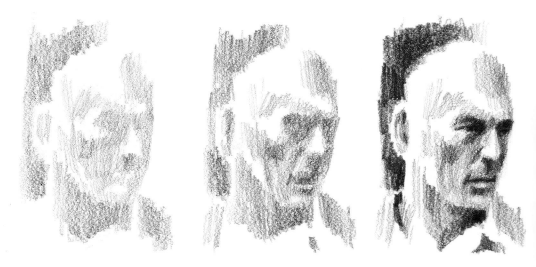

USE LAYERS OF SHADING FOR VALUE SKETCHES

Begin a value sketch by first locating the areas of highlights, which will be left white. Then lightly shade the areas of overall values. The next step is to add more layers of shading for the middle values. Finally, add the darkest shading.

USING AN ERASING SHIELD

If you want to erase in a specific area of your drawing, use an erasing shield. Place the erasing shield over the region that is not to be erased. Gently begin erasing with a kneaded eraser. Use a white vinyl eraser if the kneaded eraser doesn't fully erase the first time.

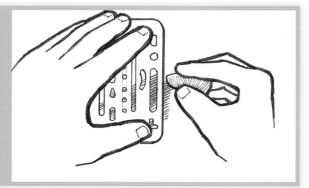

Value Sketch of a Coffee Cup

In this exercise you will be focusing on values instead of lines. Remember, this is not intended to be a finished drawing, so relax and enjoy the process.

MUST-HAVE MATERIALS

4B graphite pencil
Drawing paper
Kneaded eraser

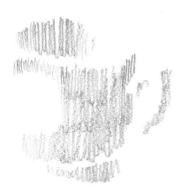

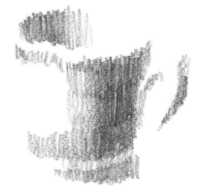

1 SKETCH THE LIGHTER VALUES

Use a 4B pencil to sketch the lighter values, keeping the lightest ones the white of the paper. Use pencil strokes that feel comfortable for you. They may be vertical, horizontal or even scribbles.

2 SKETCH THE MIDDLE VALUES

Continue adding layers for the middle values, gradually giving form to the sketch.

3 SKETCH THE DARK VALUES

Finish by adding more layers for the darkest values. Use a kneaded eraser to lighten some areas if you think they need it.

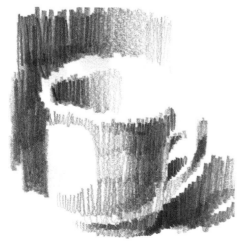

Black-and-White Sketches

Black-and-white sketches are like value sketches, except that you focus on the contrasting blacks and whites and ignore the middle values. Your softest 4B pencil will work, but charcoal and carbon pencils work especially well for this because of their rich, dark qualities. Also called *chiaroscuro* sketching, this type of sketch is a good exercise for understanding what makes images visually identifiable with the most basic of values, black and white.

 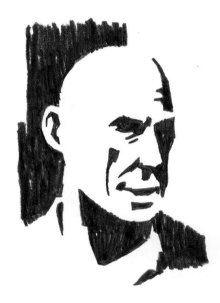

NO OUTLINES OR MIDDLE VALUES ALLOWED
No matter what part of the subject you're drawing, use only black and white forms to define it for a *chiarosuro* drawing.

AVOID SMUDGES

As you are drawing, your hand glides over the paper surface and can smear the pencil lines. One solution to this is to use a *slip sheet*, which is a sheet of paper placed between your hand and the drawing surface. This way your hand does not rest directly on the drawing.

Chiaroscuro Coffee Cup

This is like taking a value sketch to the extreme; no outlines and no middle values will be used to interpret the subject. Use this method to examine a subject's most basic lights and darks.

Remember, this is just a study. This is not intended to look like a finished drawing.

MUST-HAVE MATERIALS

Anything from a 4B to 8B graphite, carbon or charcoal pencil
Drawing paper
Kneaded eraser

1 START WITH THE MOST OBVIOUS DARKS

With a soft-lead pencil, sketch the most noticeable darks of the subject. In this case, the interior of the mug, along the rim, and down the right on the outside of the mug are the darkest areas. Keep your pencil strokes close together so areas will look black.

2 ADD MORE DARKS

Continue adding darks, using them to define the image.

3 ADD A BACKGROUND

Finish adding darks to complete the mug. Add a background and some shadows to further define the image.

Contour Sketches

This type of sketch is also called a *continuous line sketch* because you draw with one continuous line, drawing outlines and defining value areas. Don't worry about accuracy. This is a fun exercise for loosening up before you draw, and it will sharpen your observation skills. Add more of a challenge by blocking your view of the sketch in progress, letting your hand guess at what the pencil line looks like on the paper. This is called *blind contour sketching*.

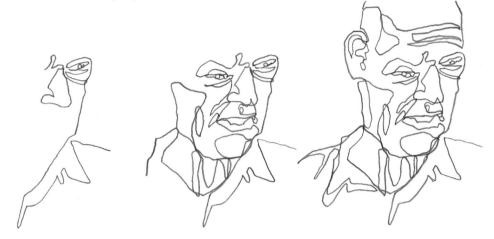

CONTINUOUS LINE SKETCH
Once you start moving your pencil, don't lift it until the sketch is done.

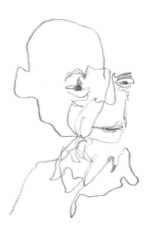

BLIND CONTOUR SKETCH
This sketch was done by observing the subject without looking at the drawing paper. Block your view of the sketch with a piece of cardboard until you're finished.

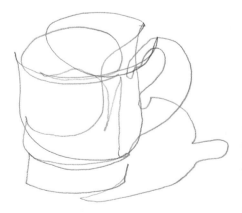

BLIND CONTOUR SKETCHES HELP YOU UNDERSTAND YOUR SUBJECT
No one expects contour sketches to be identifiable.

Contour Sketch of a Coffee Cup

This sketch is done by placing the pencil onto the paper and not lifting it until the sketch is finished. Look for lines and shapes. Follow the contours that define the subject and the shadows around it. Doing a contour sketch is truly an exercise in putting observation into practice!

MUST-HAVE MATERIALS

HB graphite pencil
Drawing paper
Kneaded eraser

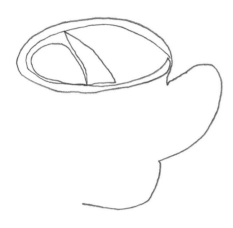

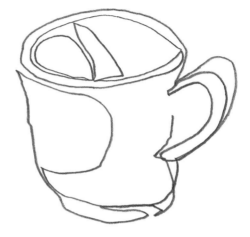

1 START MOVING THE PENCIL
Put an HB pencil to the paper and start moving it, following the contours of the subject without lifting the pencil from the paper.

2 CONTINUE THE PENCIL MOVEMENT
Keep moving the pencil so that the sketch is formed with a single line.

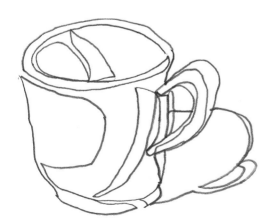

3 FINISH UP
Keep moving the pencil until the sketch is complete.

Combining Approaches

You can combine some of the different approaches to achieve a more finished drawing. For instance, start with a structural line sketch and then add values.

A light box is a device that allows you to see the structural lines for a drawing without having to draw them on the artwork itself.

First, create a structural sketch of your subject. Place the structural sketch on the light box, then tape a piece of drawing paper to the structural line sketch. The image will be visible through the drawing paper to provide a foundation for your value, black-and-white and contour drawings.

COMBINE APPROACHES FOR A FINISHED DRAWING
Work out proportions with a structural sketch and placement of the elements in your composition. Add value changes to define form and shadow.

A LIGHT BOX MAKES COMBINING DRAWING APPROACHES EASY
Do a structural sketch of your subject, erase obsolete guide lines and add detail lines defining the form and shadows. Use this sketch as the basis for a value sketch, black-and-white sketch or contour sketch. Place the sketch on a light box and then place your drawing paper on top of the sketch. Turn on the light box so the image of the sketch will be visible through the drawing paper. This will provide a framework for your subject so you don't have to sketch the structural guidelines onto the drawing paper.

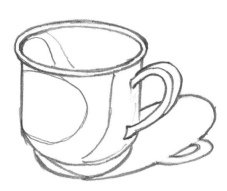

STRUCTURAL LINE SKETCH
These lines indicate highlights and shadows as well as the structure of the subject. To use other drawing approaches, erase any obsolete markings.

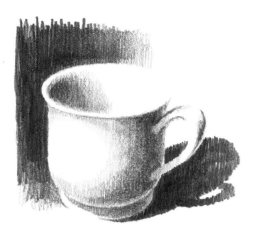

VALUE DRAWING USING THE STRUCTURAL LINE SKETCH AND LIGHT BOX
A light box was used to backlight the structural sketch as a guide for this value drawing.

BLACK-AND-WHITE DRAWING (CHIAR-OSCURO) USING THE STRUCTURAL SKETCH AND LIGHT BOX
A light box was used to backlight the structural sketch as a guide for this black-and-white drawing.

CONTOUR DRAWING USING THE STRUCTURAL SKETCH AND LIGHT BOX
A light box was used to backlight the structural sketch as a guide for this contour drawing.

Using Basic Shapes

Before you pick up a pencil to begin drawing, take time to observe your subject matter. Look for the basic shapes, then sketch them lightly on your drawing paper, working out the correct proportions of those shapes and determining where each should be in relation to one another. If you have questions about the composition, do a few quick *thumbnail sketches* at this point. Once you decide where to place the major elements of your composition, take your sketch to the next step, adding structural details. Finally, add the values. This method of drawing will help ensure that the results will be proportionally correct.

MUST-HAVE MATERIALS

HB graphite pencil
Drawing paper
Kneaded eraser

1 LOOK FOR THE BASIC SHAPES
Look for circles, squares, triangles, ovals and rectangles in your subject before you sketch.

2 SKETCH THE BASIC STRUCTURE
Start with the basic shapes and use them to work out proportions and composition.

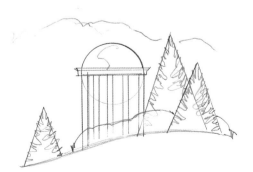

3 ADD DETAILS TO THE STRUCTURAL SKETCH
Add the details including the columns and trim to the building, define the shape of the trees and add a row of shrubs in front of the building.

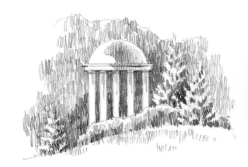

4 ADD THE VALUES
Add values over the lines to give the scene depth and definition, and to make it look more realistic.

Perspective

Atmospheric perspective, also referred to as aerial perspective, uses definition and values to create the illusion of depth and distance. Atmospheric perspective relies on the idea that the closer something is to the viewer, the more it is defined and the more its values contrast. There are other ways to show perspective, also.

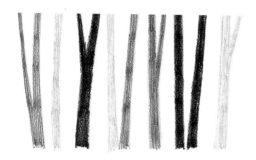

USING VALUES TO CREATE DEPTH
In this grouping of trees, the value of the closest trees contrasts more against the background than those farther away.

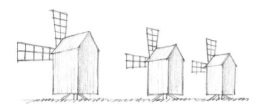

LINEAR PERSPECTIVE ONLY
Depth in this scene relies on the size differences established by linear perspective. The larger windmill seems closer to the viewer than the smaller ones. Atmospheric perspective is not used to show the distance between the windmills.

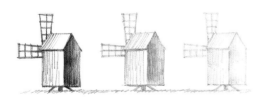

ATMOSPHERIC PERSPECTIVE ONLY
All three windmills are the same size, so no linear perspective is used. The only difference is the intensity of their values, which makes them look like they are progressively more distant, going from left to right.

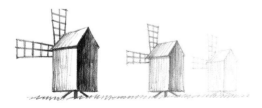

COMBINED PERSPECTIVES
By combining linear and atmospheric perspectives, the depth of the scene is expressed through size and value contrast.

Contrast

Differing values create contrasts that can affect the mood and composition of a drawing. The more extreme the difference between values, the greater the contrast. One way to achieve higher contrast in your drawing is to place your darks and lights side by side.

IT'S ALL RELATIVE
Value contrasts are relative. They appear differently according to their environment. The small square on the far left may appear darker than the small square on the near left, but both are the same value. The square on the left appears darker because it is placed directly against the pure white of the paper, providing more contrast.

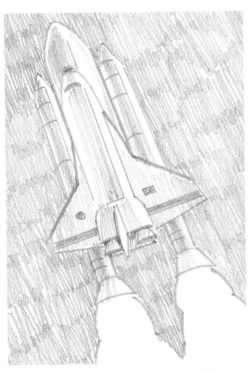 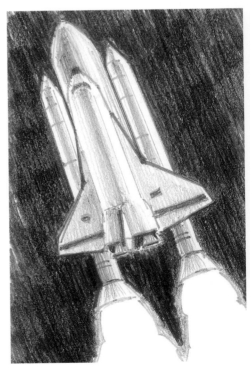

VALUE CONTRAST CREATES IMPACT
A drawing done without much contrast will not have much impact and will look flat and pale. The white smoke of the rocket on the right looks brighter against the dark background. The drawing on the right uses richer values, creating more contrast.

Making a Value Scale

You can use a *value scale* to compare the values of a scene with that of a drawing. Hold the value scale up to the subject and look through the holes punched along the side. Where do the values in the subject fall on the value scale? As you begin to compose a drawing, it is always best to establish the highlights and very light areas. Sketch those in, then look for where the other values are in the subject. To fill in the other values, one option is to go from the lightest shades of the drawing to the darkest. Another way to map out the values is to fill in some of the darkest areas around the lightest areas, then work with the midtones last.

MUST-HAVE MATERIALS

4H, HB, 4B graphite pencils
4" × 8" (10cm × 20cm) drawing paper
Kneaded eraser
Hole punch
Scissors
Ruler

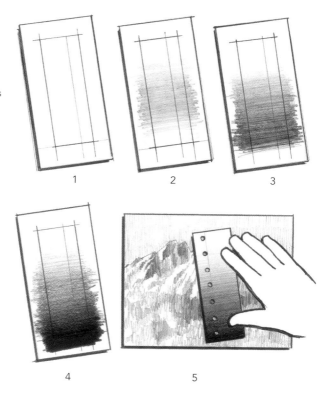

1 2 3

4 5

1 DRAW A RECTANGLE
Draw a 2" × 6" (5cm × 15cm) rectangle on a 4" × 8" (10cm × 20cm) piece of drawing paper. Add a line down the middle right of the rectangle as a guideline for the holes you will punch out in the last step.

2 CREATE THE LIGHTER VALUES
Keeping the top white, use a 4H pencil to create the lighter values with back-and-forth strokes.

3 ADD THE MIDDLE VALUES
Add the middle values with an HB pencil.

4 ADD THE DARKEST VALUES
Use a 4B pencil for the darkest values. With scissors, trim around the rectangle pattern you drew, and punch seven holes along one side with a hole punch.

5 MAP OUT THE VALUE VARIATIONS IN YOUR REFERENCE PHOTOS
Now you can hold your scale up to a picture or scene to judge the values as you work on your drawings.

Creating Values

When you draw, you use lines to suggest light and dark values. The grade of pencil, the sharpness of its point, the angle of the point on the paper, the amount of pressure applied to the pencil, and the surface of the paper all influence the values you create. Even the pencil strokes you use influence the values you create on the paper.

Often type of stroke and the direction of the lines is determined by the subject. When

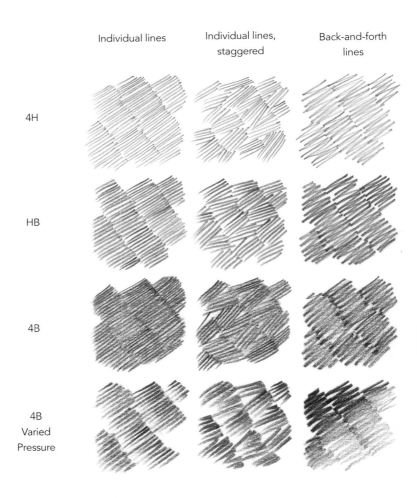

	Individual lines	Individual lines, staggered	Back-and-forth lines
4H			
HB			
4B			
4B Varied Pressure			

MAKING THE GRADE

Here are some basic lines strokes created with different pencil grades. Hard pencils are good for sharp, crisp line work, and they keep their points longer than soft pencils. Soft-grade pencils can make smooth, dark values. Consider duplicating these pencil strokes as an exercise, then get creative and invent other textures.

drawing wood, the pencil lines will follow the direction of the grain; when drawing a cat, the direction of the pencil lines will follow the contours of its body.

| Back-and-forth lines, staggered | Crosshatching | Crosshatching, back-and-forth | |

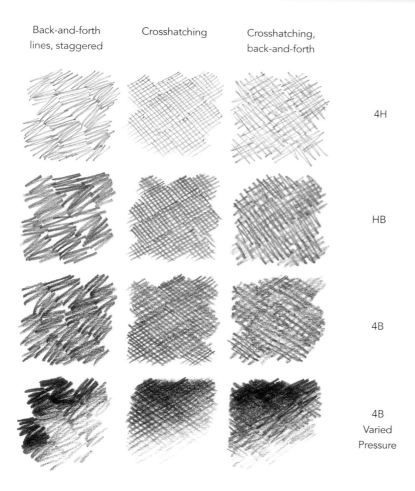

4H

HB

4B

4B
Varied
Pressure

Light Effects

Values are used to create the effects of light and shadow. To make your drawings look realistic, you will need to replicate these different light effects.

- **Light Source**. Basically, the origin of the light. To determine the shading and shadows of a scene, it is important to determine the position of the *light source* so you know from which direction the light is coming. The light source is usually the sun or a lamp, so the light usually comes from the top. A light source positioned at the top left or right will give more depth than one located straight above your subject.

- **Highlight**. A *highlight* occurs where light reflects off an object. In a drawing, this appears as a bright spot.
- **Form Shadow**. A shadow on an object that gives depth and dimension to its form.
- **Cast Shadow**. A shadow that is cast or thrown by one object onto another surface.
- **Reflected Light**. Light that bounces off a surface and adds light to a region of the object that would otherwise be darker.

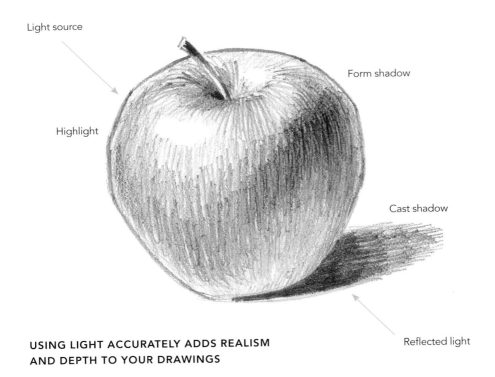

Light source

Form shadow

Highlight

Cast shadow

Reflected light

USING LIGHT ACCURATELY ADDS REALISM AND DEPTH TO YOUR DRAWINGS

Clouds and Grass

The world around us offers an infinite number of subjects to draw. Commonplace items such as clouds and grass can be interesting by themselves or as complements to other elements in a picture.

When drawing clouds, start by sketching the outline, but use subtle value changes to show the shape and depth of their forms. You can achieve value changes by varying the type or pressure of your pencil strokes. Be particularly conscious of the location of your light source. Stormy days while the sun is still out are especially good for drawing clouds because there are so many sharp contrasts between the lights and darks of the sky.

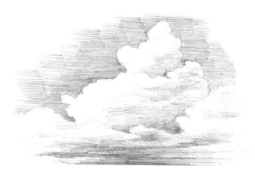

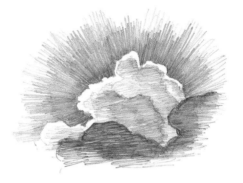

CLOUDS IN SUNLIGHT
With the light source above, the tops of the clouds appear lighter, while the undersides appear darker and shadowed. One way to learn how to draw clouds in sunlight is to study the effects of light on something more solid, such as cotton balls.

CLOUDS BLOCKING THE SUNLIGHT
Clouds can be both translucent and opaque. When the light source is behind the clouds, the cloud in front of the sun will appear bright white around the thin, translucent edges where the light shines through it. The thicker parts of the cloud will appear darker because they are more opaque, blocking more of the light.

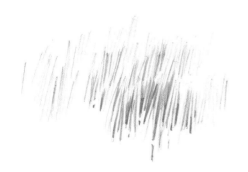

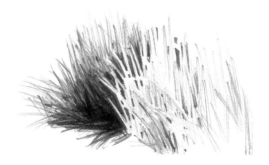

GRASS IN SUNLIGHT
Line strokes can imply individual blades of grass. Use darker strokes to indicate shading and depth.

GRASS IN SUNLIGHT AND SHADOW
The background grass is shown as a dark silhouette, whereas the foreground grass is suggested with light pencil strokes. Vary the direction and spacing of the lines to make the grass look more interesting.

Evergreen Trees

When drawing a tree, examine the subject closely to capture its uniqueness.

MUST-HAVE MATERIALS

Graphite pencil
Drawing board
Drawing paper
Kneaded eraser

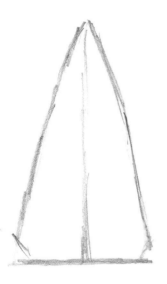

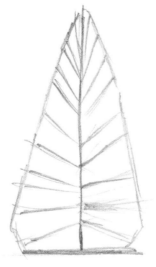

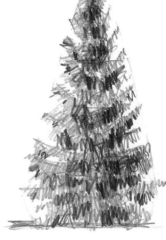

1 SKETCH THE BASIC SHAPE

Start with the basic overall shape and trunk.

2 SKETCH THE BRANCHES

Sketch in the branches, noticing their direction. The branches angle downward the farther down you place them on the tree. Many trees are structured like this, not only evergreens.

3 ADD THE NEEDLES AND SHADING

Erase any unnecessary lines. Use a variety of staggered back-and-forth lines to suggest the needles of the tree. Apply some lines more heavily than others to create shading and depth.

Rocks

Apply the same drawing principles and techniques that are used when drawing complex subjects to relatively simple subjects such as rocks. You can make the drawing more interesting by varying the shapes and sizes of the rocks.

MUST-HAVE MATERIALS

Graphite pencil
Drawing board
Drawing paper
Kneaded eraser

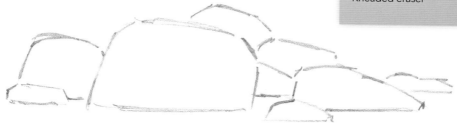

1 SKETCH THE BASIC SHAPES

Sketch the outer shapes of the rocks, varying the sizes and shapes for interest.

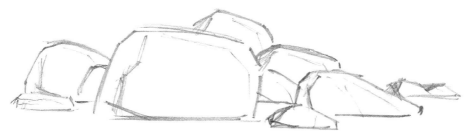

2 MAP OUT THE LIGHTS AND DARKS

Add lines to map out the lights and darks on the rocks. In this case, the light comes from the upper right, so draw lines on the upper right areas of the rocks for the highlights and on the lower left areas for the darkest portions of the rocks.

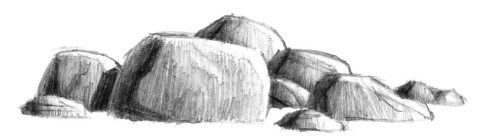

3 ADD SHADING AND SHADOWS

Use consistent up-and-down pencil strokes so that the surface of the rocks will look smooth. Make the pencil strokes darker on the left side of the rocks to create shading and depth.

Swan

The elegant lines of this swan make it an interesting subject.

MUST-HAVE MATERIALS

Graphite pencil
Drawing board
Drawing paper
Kneaded eraser

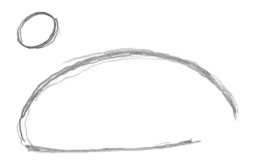

1 SKETCH THE BASIC SHAPES
Sketch the basic shapes of the head and body. Be conscious of their proportions and placement.

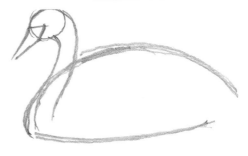

2 ADD THE NECK AND BEAK
Add curved lines for the neck, then add the beak, paying attention to the distance between the neck lines.

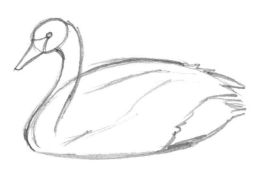

3 SKETCH IN THE FEATHERS
Indicate the feather placement on the swan's back, and add the eye to the head.

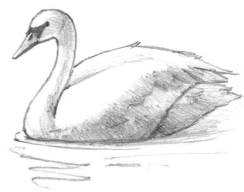

4 ADD FINAL DETAILS AND SHADING
Add the shading with short pencil strokes. Start with the lighter values, then add another layer of pencil strokes for the darker areas.

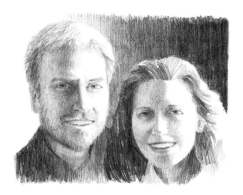

ABOUT THE AUTHORS

Mark Willenbrink is a freelance illustrator and fine artist whose work has been displayed in fine art shows, with several paintings receiving awards. Mark also teaches art classes and workshops using demonstration, simple instructions and professional tricks to help his students achieve beautiful artwork they can be proud to display.

Mary Willenbrink has her master's degree. She is a Christian counselor and author, but feels her highest calling is to be home to raise her children.

As a husband and wife team, Mark and Mary have authored and illustrated *Watercolor for the Absolute Beginner* (North Light, 2003), and the book has been translated into several languages. Mark's writings and illustrations have been featured in a number of other art instruction books. Mark is a contributing editor for *Watercolor Artist*. His regularly featured column, "Brush Basics" has been rated as a favorite among the magazine's readers.

Mark and Mary reside in Cincinnati, Ohio.

Today's Artist: Drawing for the Beginner Workshop. Copyright © 2011 by Mark and Mary Willenbrink. Manufactured in China. All rights reserved. No part of this book may be reproduced in any form or by any electronic or mechanical means including information storage and retrieval systems without permission in writing from the publisher, except by a reviewer who may quote brief passages in a review. Published by North Light Books, an imprint of F+W Media, Inc.,10150 Carver Rd, Blue Ash, OH 45242 (800) 289-0963. First Edition.

Other fine North Light Books are available from your favorite bookstore, art supply store or online supplier. Visit our website at www.fwmedia.com.

15 14 13 5 4 3 2

DISTRIBUTED IN CANADA BY FRASER DIRECT
100 Armstrong Avenue
Georgetown, ON, Canada L7G 5S4
Tel: (905) 877-4411

DISTRIBUTED IN THE U.K. AND EUROPE
BY F&W MEDIA INTERNATIONAL, LTD
Brunel House, Forde Close, Newton Abbot, TQ12 4PU, UK
Tel: (+44) 1626 323200, Fax: (+44) 1626 323319
Email: enquiries@fwmedia.com

DISTRIBUTED IN AUSTRALIA BY CAPRICORN LINK
P.O. Box 704, S. Windsor NSW, 2756 Australia
Tel: (02) 4577-3555

Designed by Wendy Dunning
Production coordinated by Mark Griffin

METRIC CONVERSION CHART		
To convert	to	multiply by
Inches	Centimeters	2.54
Centimeters	Inches	0.4
Feet	Centimeters	30.5
Centimeters	Feet	0.03
Yards	Meters	0.9
Meters	Yards	1.1

Ideas. Instruction. Inspiration.

These and other fine North Light products are available at your favorite art & craft retailer, bookstore or online supplier. Visit our websites at artistsnetwork.com and artistsnetwork.tv.

GET YOUR ART IN PRINT!
Go to splashwatercolor.com for up-to-date information on all North Light competitions. Email us at bestofnorthlight@fwmedia.com to be put on our mailing list!

Get the latest updates, free downloads and more!

FOLLOW US!